How to make
SALT DOUGH MODELS

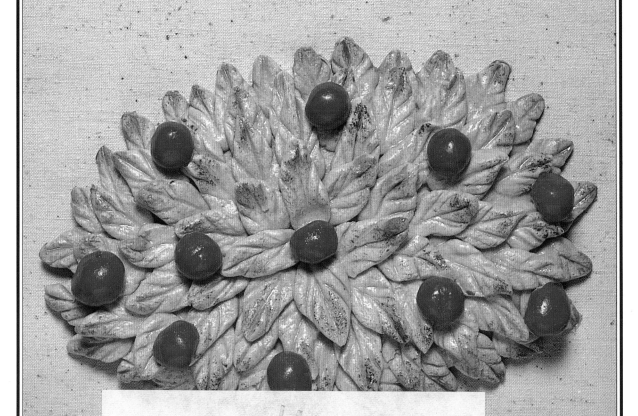

How to make
SALT DOUGH MODELS

Sue Organ

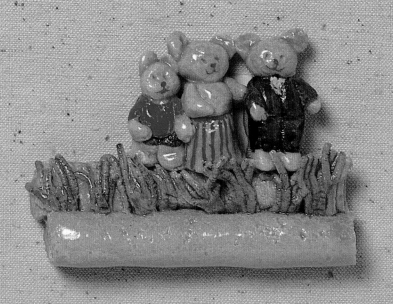

SEARCH PRESS

First published in Great Britain 1993
Search Press Limited
Wellwood, North Farm Road,
Tunbridge Wells, Kent TN2 3DR

Reprinted 1995, 1996, 1998

ISBN 0 85532 756 1

If you have difficulty in obtaining any of the materials or
equipment mentioned in this book, please write for further
information to the Publishers.
Search Press Limited
Wellwood, North Farm Road
Tunbridge Wells, Kent TN2 3DR
England

Printed in Spain by Elkar S. Coop, Bilbao 48012

Contents

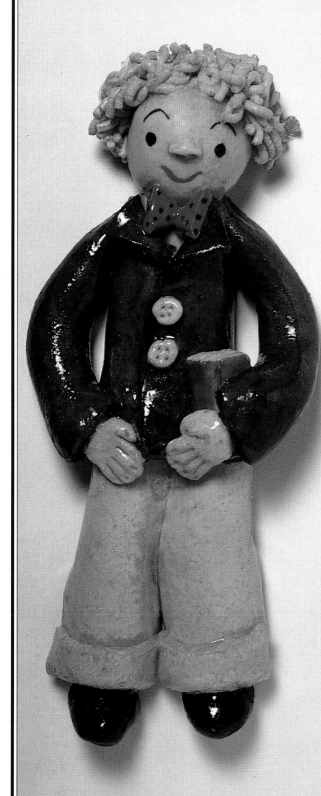

Introduction

Salt dough modelling is not a difficult craft, and I am sure that you will be delighted even by your first results. As its name implies, the dough is made from salt, flour, and water, and it can be used to make a whole range of attractive figures and plaques. These are then baked in a domestic oven, painted, and varnished to preserve them.

In this book, I hope to introduce you to a range of techniques. Practical information on making and working with salt dough is followed by a series of clearly illustrated step-by-step instructions which show how to make a variety of models from simple animals and figures to intricate scenes and name plaques. Once you have tried some of these models and are familiar with the basic techniques, you can begin to develop your own ideas for designs. The real fun lies in making your own original table and wall decorations, or maybe a really personal present for a friend or child. So, good luck – I am sure that you will find many absorbing and happy hours ahead of you.

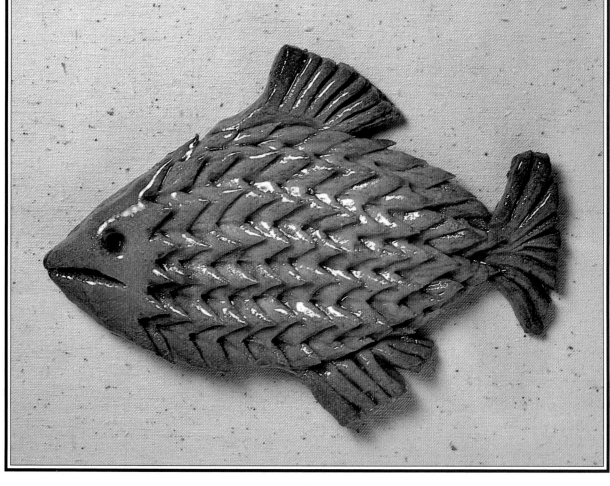

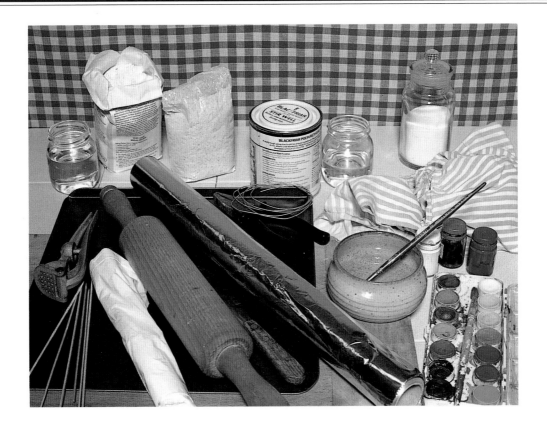

Materials & equipment

Salt dough is not expensive to make, and you will probably find that you have most of the equipment already. To begin, you need the following:

Materials Plain white flour; cooking salt; ordinary cooking oil; water; water-based paints, e.g. a child's box or some poster paints; polyurethane high gloss household varnish; white spirit.

Equipment Baking tray; aluminium foil; medium strength galvanized wire and wire-cutters/pliers; rolling-pin; kitchen knife; craft knife; small bowl and a brush; paintbrush; sheet of polythene upon which to varnish the models; a cloth; bamboo barbecue sticks or cocktail sticks to use as modelling tools; garlic press (this is very useful for making hair, but you can start without one).

Dough

Before you tackle your first salt dough model, I suggest that you read this section carefully as it contains all of the general information that you need to know about making and working with salt dough.

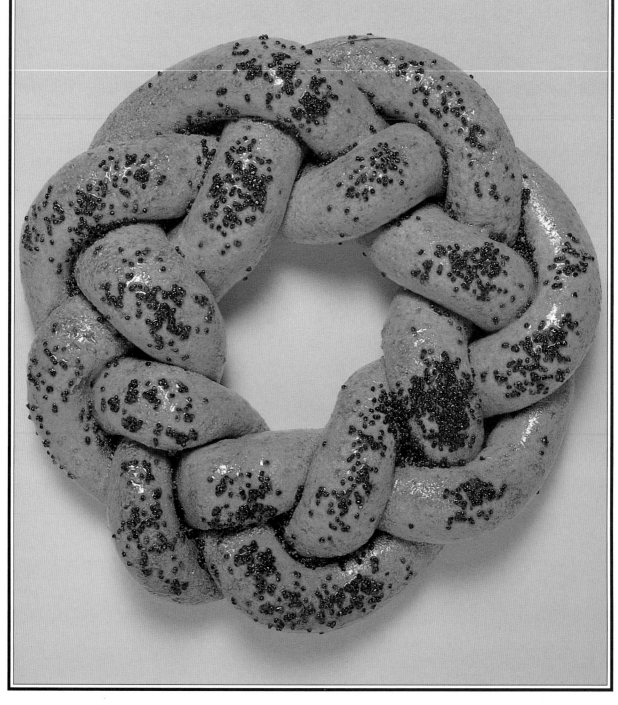

Recipes

Basic dough

3 cups of plain flour; 1 cup of salt; 1 cup of water; a dribble of cooking oil.

Mix the ingredients to form a dough. Turn this on to the table and knead it for a minute or two. It should feel like pliable pastry dough. If it is too dry, then add a little water. Leave the dough for about half an hour before using it as this makes it easier to handle. Keep it in a polythene bag so that it does not dry out, and use it up within the day as old dough does not hold detailed modelling and will begin to sag.

Coloured dough

Firstly, make the basic dough. Then, simply make a well in the middle of it, add a few drops of food colouring, and knead it well. For stronger colours, add more colouring and possibly some extra flour if the dough feels too wet. Instead of food colouring, you can use cocoa or instant coffee dissolved in water.

Rye dough

This has a warm, rich colour and is especially suitable for bread forms. Make the dough as described in the basic recipe, but use the following ingredients: 3 cups of plain flour; 1 cup of rye flour; $1^{1}/_{2}$ cups of water; 2 cups of salt; a dribble of oil.

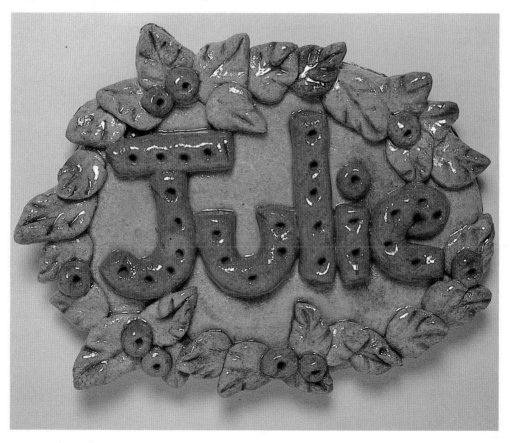

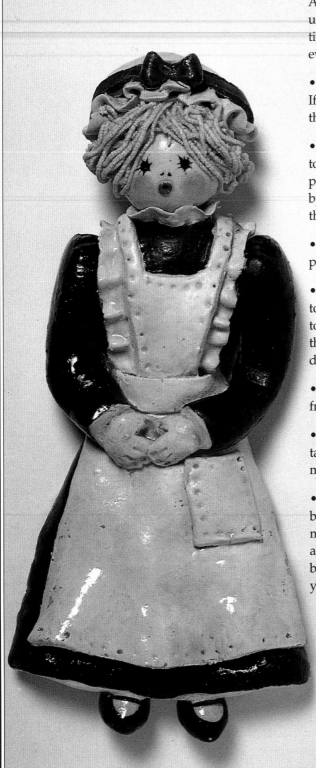

Working with dough

As with any craft, it takes a little while to get used to handling salt dough. Here are some tips to help you to create successful models every time.

• Make figures that lie flat on the baking tray. If you try to make free-standing figures, then they will sag when you bake them.

• Dough models are not very strong, so try to avoid making models with lots of delicate parts. Also, reinforce thin, protruding parts by pushing a stick or a piece of wire through the centre of the dough.

• As you make your model, reknead each piece of dough that you use.

• Always keep a bowl of water by your side to dampen the pieces of dough that you want to join together. It is best to use a brush for this, so that your fingers do not become damp and sticky.

• Keep a little flour handy to stop the dough from sticking to the table.

• Keep your dough in a polythene bag and take out only enough for the part that you are making.

• As a general rule, work straight on to a baking tray. Sometimes, you may find it more convenient to make your figure on aluminium foil and then move both on to the baking tray. This is especially useful when you want to bake several figures at once.

Textures

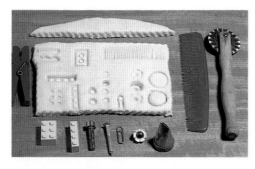
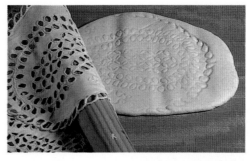

Lace, buttons, toy bricks, and many other everyday objects can be pressed into dough to make super textures. To create a lacy texture, lay a piece of lace on to your sheet of dough. Roll over it with a rolling-pin and you will be left with an impression. This can be done also with hessian, other textured cloth, or leaves.

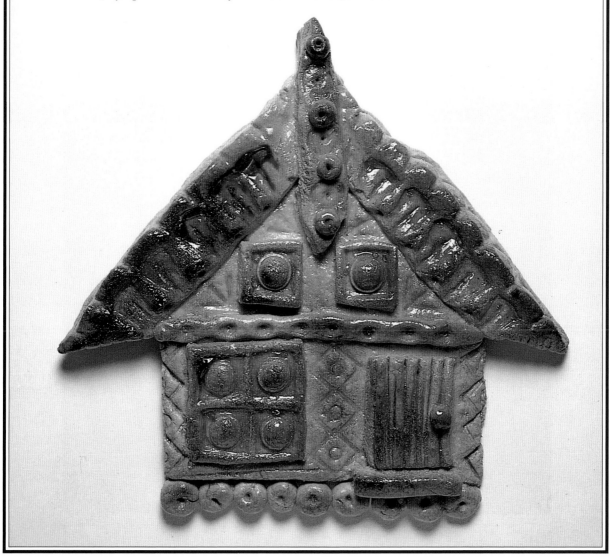

Making a hook

If you want to hang your work up, then you will need a hook. This is surprisingly easy to forget! For small items, a paper-clip sunk into the dough will do well. Larger items need one or two hooks made from twisted wire.

To make a wire hook, cut a length of wire and bend it into two. Hold the bent end of the wire firmly with your fingers and use a pair of pliers to twist the two loose ends together. Make sure that you push the hook well into the dough.

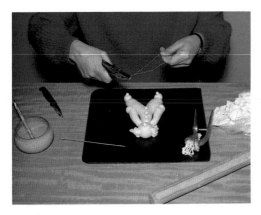 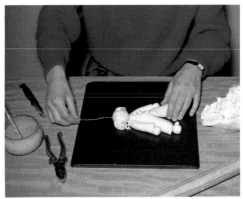

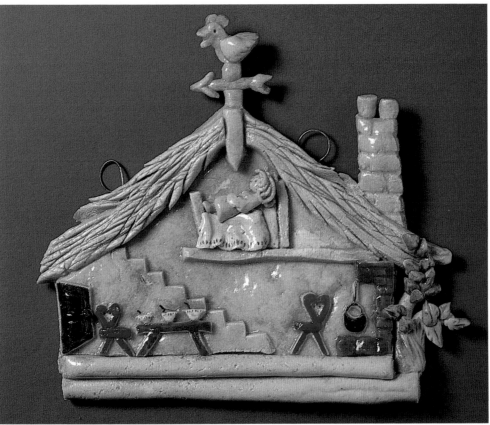

Baking

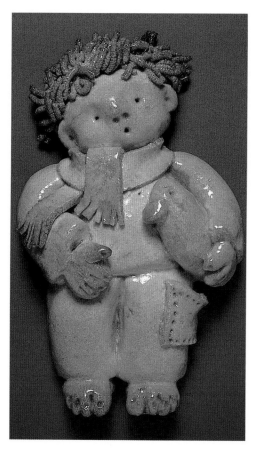

Baking both hardens and dries the dough. The model is ready once it has dried out thoroughly in the oven. A thin item, such as a plaque, will take about one hour to bake at 150°C (300°F). A thicker figure, such as this boy, will take about three hours at 100°C (210°F).

Is it ready?

If there is any sign of soft dough when you look at the back of the model, then it is not ready. I find that the best test is to tap the back with a spoon. If it rings then it is ready, if it thuds then it is not. If you are not sure of the different sounds, lightly tap the outer, well-baked edge, and then tap the central, thicker parts. They should not sound too different. Remember, dough must be dried out thoroughly or it will not keep.

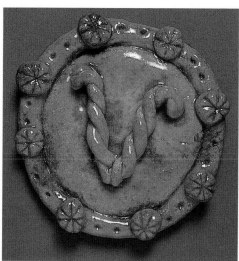

Browning

It is easy to scorch things by mistake. On the other hand, an overbrowned effect can add character to a piece, so there can be attractive mishaps! Darker touches are especially suited to natural, unpainted pieces. If you want to add browner areas, then just heat the oven further and put the model back in for a few minutes. Alternatively, put it under a low grill, but *watch it all the time*. If you want to paint the model later on, then it is best to keep the colour light. To do this, you may need to turn down the heat and leave the item to bake for a longer time. Covering thin parts with foil can prevent scorching.

Painting

There are various ways in which you can colour your models. You can make a coloured dough to begin with (see page 9), or you can rely upon altering the baking time to give a variety of browned effects (see above). Alternatively, you can paint your model once it has been baked. This can be done very simply, using a child's paint box or some pots of poster paints. After baking, always make sure that the model is completely cool before starting to paint it.

Varnishing

Varnish adds the finishing touch to your model. It gives it a rich lustre and highlights the colour. Also, it preserves your salt dough. Baked dough is rather like a dry biscuit; it can go soft if you leave it out, even in a normal atmosphere. The varnish seals the baked dough and stops it from deteriorating, but it must be applied thoroughly.

How to varnish

Materials & equipment Polyurethane high gloss household varnish; a brush (from now on it will not be of much use for anything else); polythene sheeting upon which to work (a carrier bag which has been split open will do well, as long as any printing is placed face down so that it can not come off on your work); a tray, so that once varnished you can lift the drying model out of harm's way; white spirit and a cloth, with which to clear up; a craft knife.

Method Firstly, varnish the back. Be generous with the varnish and work it into all the little crannies. Then, turn your model over and varnish the front. Leave it to dry with the wet, varnished bottom still sitting on the polythene. When it dries, the back may be rather wrinkly, but that does not matter. In order to keep well, your model will need a second coat of varnish – do not be tempted to miss this! Once the second coat is dry, any protruding dribbles of varnish can be cut off with a craft knife.

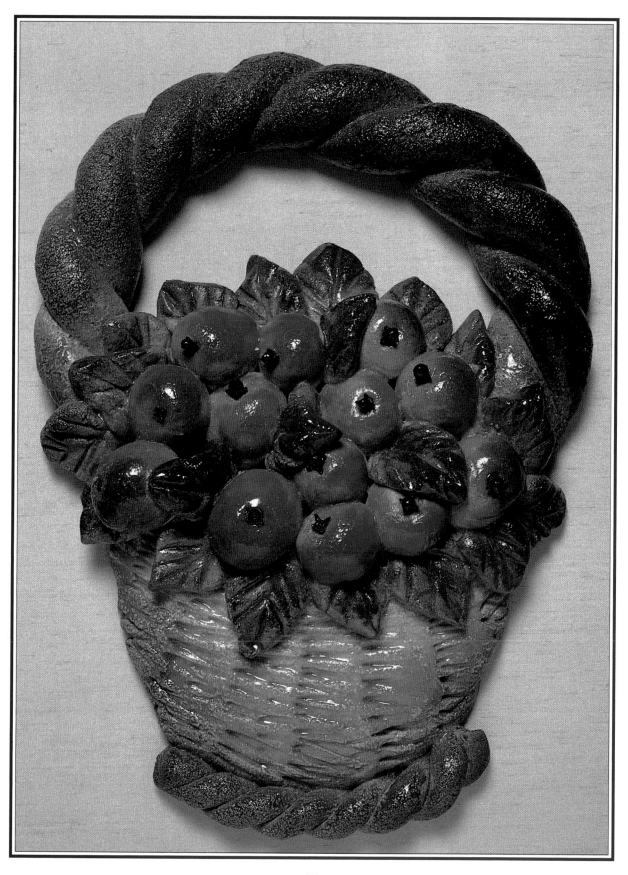

Problems

Despite all your efforts you may find that you have the odd disaster. I certainly do! Here are some of the common problems that you may encounter, together with a few tips on how to overcome them.

Your dough cracks as you use it and you cannot get a smooth finish.
- Have you left the dough for half an hour before using it?
- Try adding a little water and rekneading it.
- Try adding a little oil and rekneading it.

You are called away unexpectedly in the middle of making your model.
- Loosely wrap the unfinished model in polythene so that it does not dry out. It will be fine for a few hours.

Everything falls to bits in the oven!
- Have you used water to join the parts?
- Have you used wire or sticks to strengthen thin or protruding parts?
- Next time, try a more compact design.

Parts break off an unvarnished model.
- Stick it together with strong adhesive and then varnish it as usual.
- You could try joining the two parts with a little dough and baking the model further.

Parts break off a varnished model.
- Stick it together with strong adhesive and add a little varnish over the crack.
- You could devise a splint from a stick or a piece of wire and glue this to the back of the model in order to make it really strong.

A finished model starts to sag.
- Did you bake it for long enough?
- Did you give it two coats of varnish?
- Put the model in a warm, dry place and forget about it for a few weeks. With luck, it will dry out again and you can revarnish it.

Your creation falls off the wall!
- Would it have been better to have used two hooks to support the weight?
- Were the hooks long enough?
- Has water got into the dough?
- Try sticking the hooks back in and drying the model as explained above.

The colour of your model has faded.
- Unfortunately, strong light will fade some paints, but you can paint over varnish with oil paints.

With luck, you will be able to enjoy your salt dough model for several years, but do not be too upset if it does not last forever!

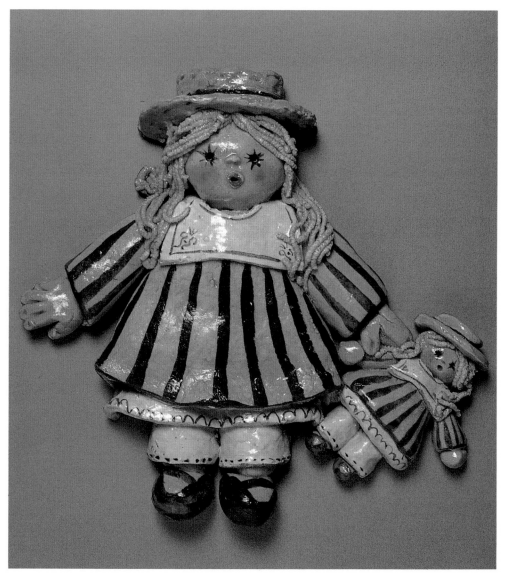

Figures & animals

This section starts with two simple figures, a clown and a girl. It is a good idea to choose one of these for your first project. Then, when you are used to working with dough, you can go on to make more advanced figures like the girl and doll shown above.

Clown

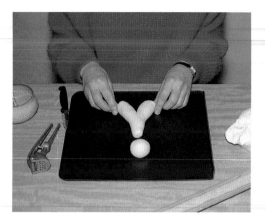

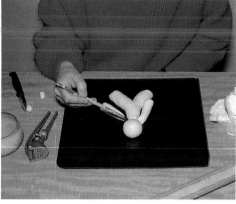

1. Roll a ball of dough for the head. Make a thick roll long enough for both the body and the legs. Slit the bottom of this and separate it into two legs. Twist each leg so that the cut edges face downwards. Wet the top of the body and join the head firmly to it.

2. Make a long roll and cut it into two to make the arms. Place one arm next to the other and trim them to the same length. This is an easy way to avoid the problem of one arm ending up longer or fatter than the other. Make the top of each arm thinner than the bottom. Join them to the sides of the body with a little water.

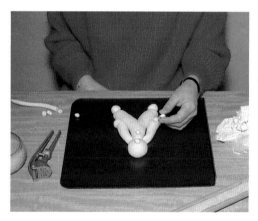

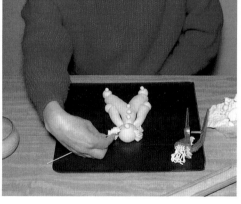

3. Make the hands and feet from four balls of dough, and join them to the body with water. Then, add six balls for the shoe bobbles, buttons, and nose.

4. Dampen the head, and press some dough through a garlic press to make the hair. To give a neat edge, twist the hair over a stick before arranging it on the head. Finally, make a hook and push it well into the head (see page 12). The clown is now ready to bake, paint, and varnish (see pages 13–14).

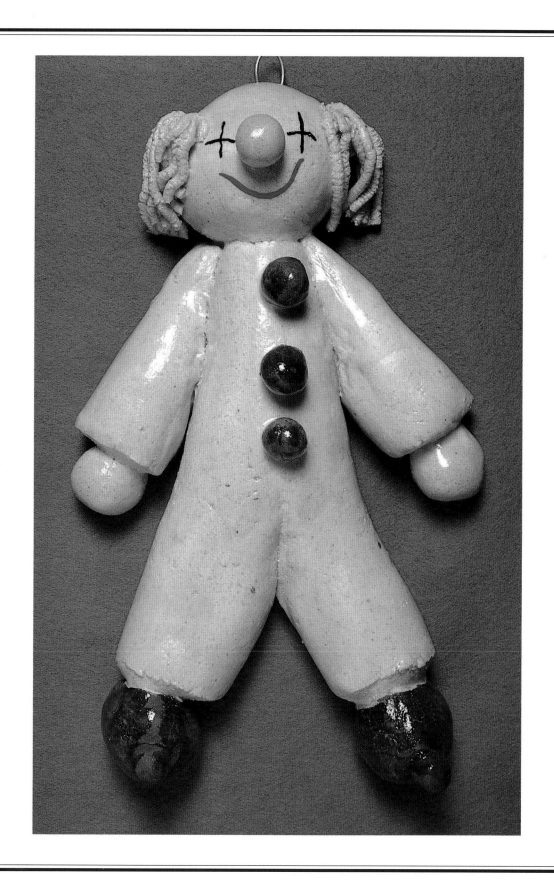

Girls

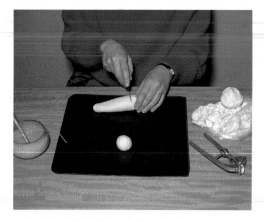

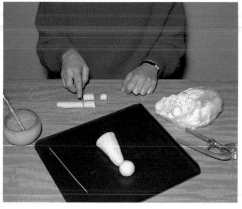

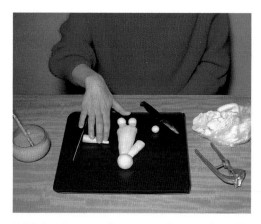

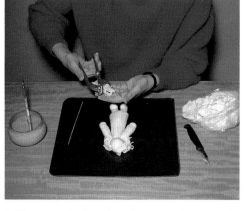

1. Roll a ball of dough for the head. Make a thick roll for the body with the neck end a little thinner. Trim the bottom of the skirt with a knife and smooth it with your finger. Wet the top of the neck and join the head firmly to it.

2. Make the arms from a roll cut into two. Place them next to each other and trim them to the same length.

3. Make the top of the arms thinner than the bottom, and then join them to the sides of the body using a little water. By putting the arms alongside the body, rather than sticking out, they will be really strong. Next, roll two legs, making them thicker than the arms. Using water, secure them to the body and to each other. Make the hands and feet from four balls of dough.

4. Dampen the head, and use a garlic press to make the hair. Remove the strands with a knife and arrange them on the head, starting at the neck and working upwards. The last piece of hair is added to the crown. Finally, add a hook (see page 12). The girl is now ready to bake, paint, and varnish (see pages 13–14).

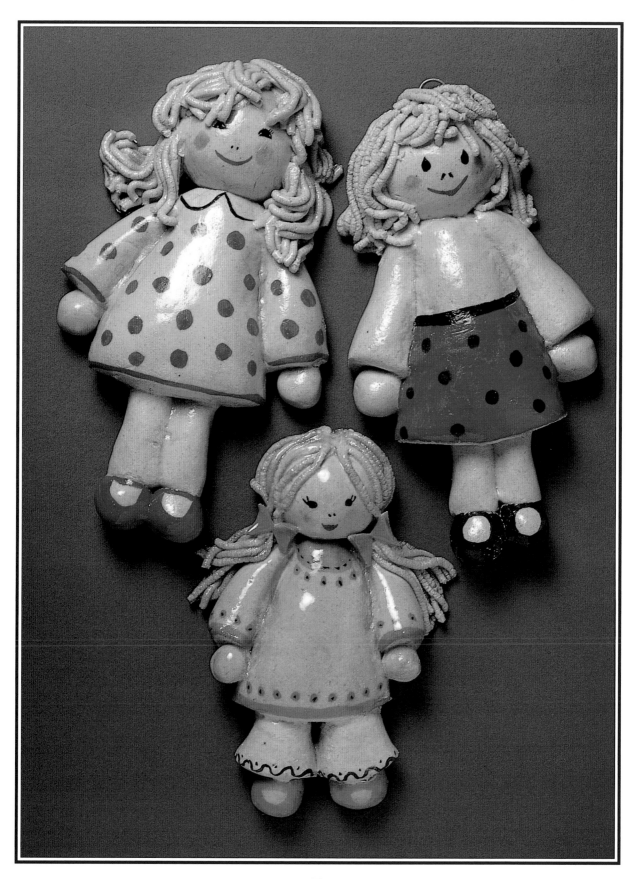

Nursery figures

These figures are made in a similar way to the clown and the girl. The rabbit has a round-shaped body and head, with balls of dough for its legs and nose, and triangular wedges for its long ears. The teddy bear is similar but has rolls of dough for its arms and legs. Also, its paws have been marked using a thin stick. It has small, semi-circular ears, two pieces of dough for its face, and a more detailed triangular nose. (Instructions for making a nose like this can be found on page 27.) In both cases, the eyes, mouth, and other facial features have been painted on.

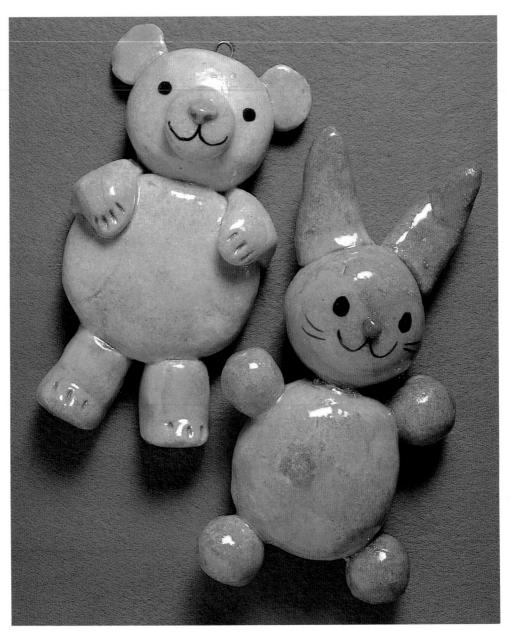

Baby

This figure has no arms and legs, just a simple body and head! It makes an original present with which to welcome the arrival of a new baby.

1. Roll out an oval sheet of dough and make a hole in it, by which to hang the finished figure. Add a head, a body, and, if you wish, two small balls of dough for hands. (Detailed instructions for making hands can be found on page 26.) Next, roll out a sheet of dough for the cot cover.

2. Place the cover over the baby and turn back the top edge. Then, join the cover to the base with a little water, pressing the edges together firmly. A different effect can be achieved by easing the cover into gentle folds. To make sure that these do not collapse in the oven, support them with small pieces of aluminium foil.

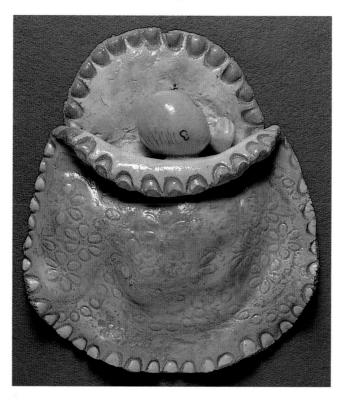

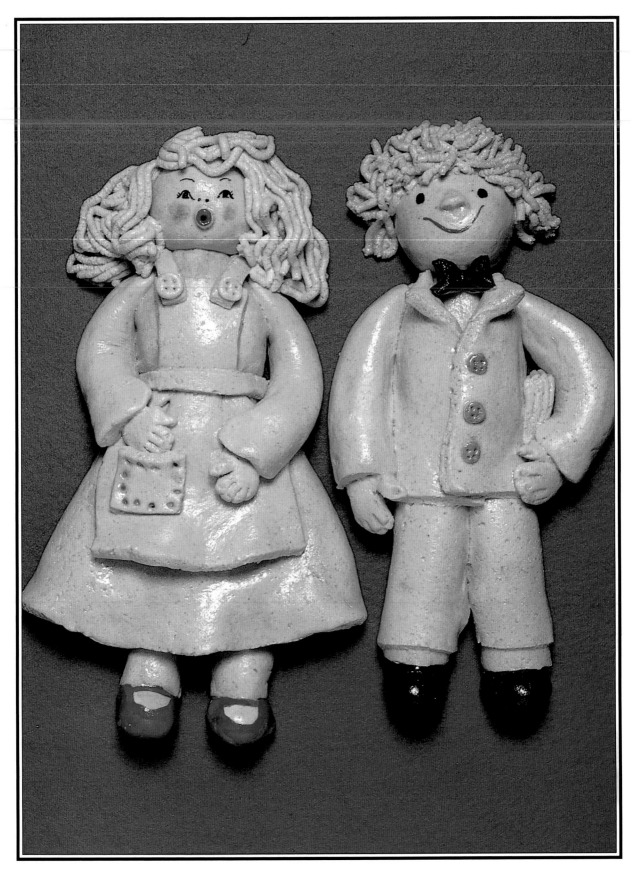

Sally & Sam

Now that you are used to handling dough, here are some more advanced figures at which to try your hand. However, before you start to assemble a more complicated figure, spend a moment thinking about the order in which you should add each of the parts. For example, if you want hair to fall over a collar then it must be added after the collar.

Sally

1. Roll a ball of dough for the head and choose the smoothest side for the face. Then, roll a shape for the body, make the legs and add them on. Take a little time to make sure that you are happy with the proportions. You will be adding layers of dough on top of this base so it is best to start with a thin figure, otherwise it may end up too bulky! Remember, if you are not happy with anything then you can always take it off and have another go.

Body, legs, and basic skirt shape.

2. Roll out a sheet of dough roughly the size of the skirt. Place it over the figure and mark with a knife where it needs cutting, allowing for gathers. Put the dough on a flat surface and cut it. You may find that, whilst you were working out the shape, the skirt became stretched and lost its fresh look. If this is the case, then just roll out and cut a new piece, using the first as a template.

Placing the skirt over the body.

3. Secure the skirt round the waist and fold the side edges under. (If you wish, then you can add a second, shorter skirt as well.) To make sure that the folds along the bottom of the skirt do not collapse in the oven, support them with small balls of foil. Remove these after baking.

4. Cut the shape for the bottom part of the pinafore. (You may find it best to use your first attempt as a pattern for the final shape.) Now make the bib. Cut thin strips for the shoulder straps and waistband, and add them to the figure. Next, add the feet and arms.

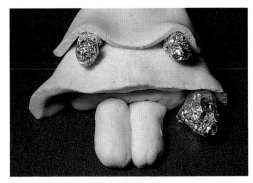
Supporting the folds of the skirts with balls of foil.

5. Pockets are fun to make. Just cut a square and dampen three sides. With your finger under the top edge, use a stick to make a stitching pattern around the other three edges. This will also secure the pocket to the pinafore.

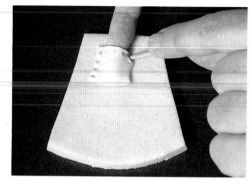

Making a pocket.

6. To make a hand, firstly roll a small ball of dough. Flatten it slightly and use a stick to divide off the thumb. Then, use the stick to mark a flat line between the fingers, but do not separate them off. Use the blunt end to make little impressions for finger nails. You may need several attempts before you are happy with the hands. If they are still a problem, then remember that you can always use small balls of dough instead.

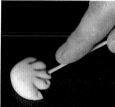

Making a hand.

7. Squeeze some dough through a garlic press to make the hair. For longer hair, keep adding dough at the top of the press. To make wavy hair, hold your hand just under the press. As the dough comes out, it will wave as it touches your hand. Dampen the head and, starting at the base, arrange the hair.

8. For the mouth, put a small ball of dough on the pointed end of the stick. Press this into the face. As you take the stick away, a small circle of dough will remain. Sally is now ready to bake, paint, and varnish.

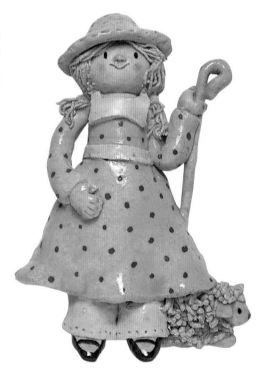

With a little imagination, you can change Sally into Bo Peep! (Information on making the sheep can be found on page 28.) The figures illustrated on pages 5, 10, and 17 are also variations of Sally and Sam.

Sam

1. Make a ball of dough for the head and rather thin rolls for the body and legs. They are to be covered with clothing and must not end up too bulky.

2. Cut two rectangles for trouser legs. Tuck them round the legs.

3. It may take a couple of attempts before you are happy with your first coat. Roll out a sheet of dough large enough to cover the body. Cut a 'T' shape, as shown, and discard the top piece. Turn back the corners of the two remaining pieces to make the collar.

4. Hold the coat against the body and mark how large it should be. If it stretches, then use it as a template. Place the first part of the coat on the body and tuck the edge round the side.

5. Do the same for the second side. Then, add small flattened balls for buttons. Prick them with a stick to indicate holes. If anything looks stretched or cracked, then just take it off and have another go.

6. For the book, make a block of dough and use the back of a knife to suggest pages. Next, add the arms, hands, hair, and bow tie.

7. For the nose, roll a small ball of dough and stick it on to the face. Now, use a stick to flatten the sides, making a triangular shape. Finally, use the flat end of your stick to make nostrils. If you press slightly harder, then the dough will spread and look more realistic. If you are not happy with the result, then take the nose off, smooth the face with a slightly damp finger, and start again. The figure is now ready to bake, paint, and varnish.

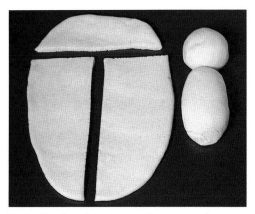

Body, head, and basic coat shape.

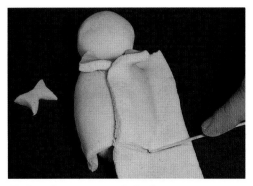

Fitting the coat on to the body.

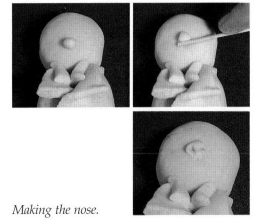

Making the nose.

Animals

A small pair of scissors can be used to wonderful effect with salt dough, to make the feathers of a bird, the spines of a hedgehog, or the scales of a fish (see page 6). Equally, a 'squirt' of dough from a garlic press makes an attractive sheep. With just a little imagination, I am sure that it is possible to create a whole menagerie in dough!

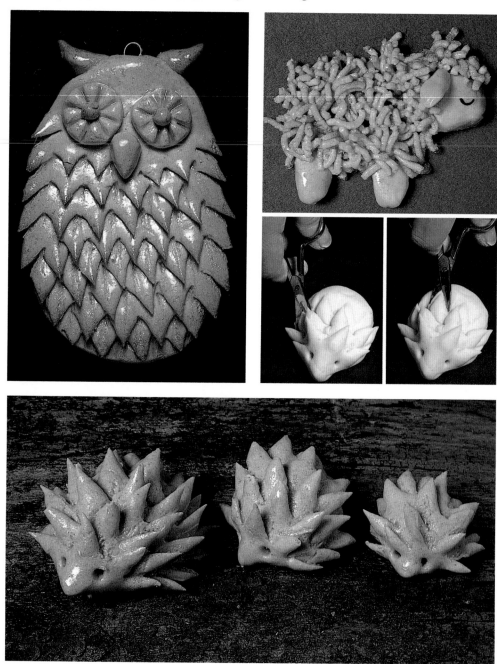

Trees, garlands, & baskets

This section shows how to make an attractive range of plaques, garlands, and table decorations, all of which are decorated with either fruits, flowers, or bread.

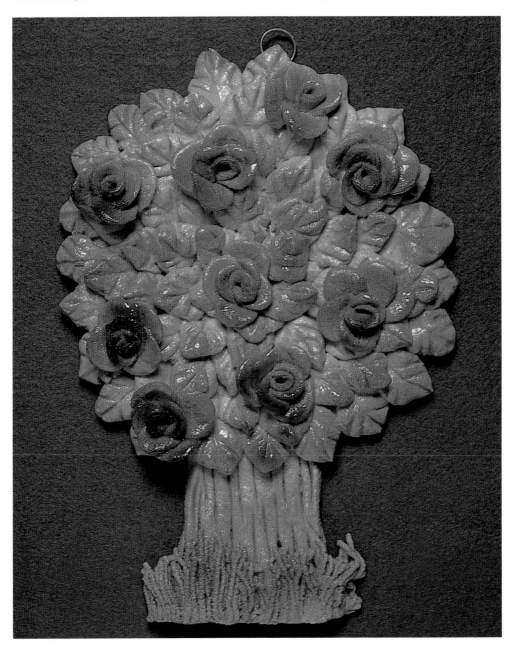

Tree

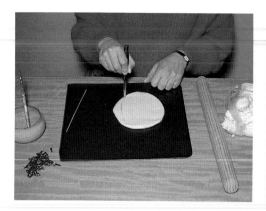

1. To make the base, roll out the dough. Mark the shapes of the tree and cut them out.

2. To make sure that all of the leaves are of a similar size, firstly roll out a length of dough. Cut this up into equal slices and use each slice to make a leaf. This ensures that the same quantity of dough is used for each one. Flatten the slice on the palm of your hand and pinch the ends into points. Lastly, use a stick or a knife to mark the veins.

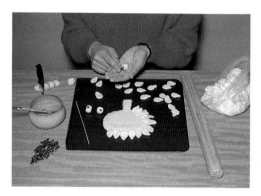

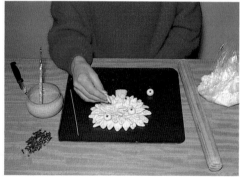

3. Dampen the base and add the leaves, starting from the outside and working inwards. To make all of the apples the same size, roll the dough and slice it up evenly. Roll each slice into a ball and stick a clove into it to give the characteristic appearance of an apple.

4. Add the apples to the base. Finally, texture the trunk with the back of a knife. The tree is now ready to bake and varnish.

Variations of this tree can be found on pages 1 and 29.

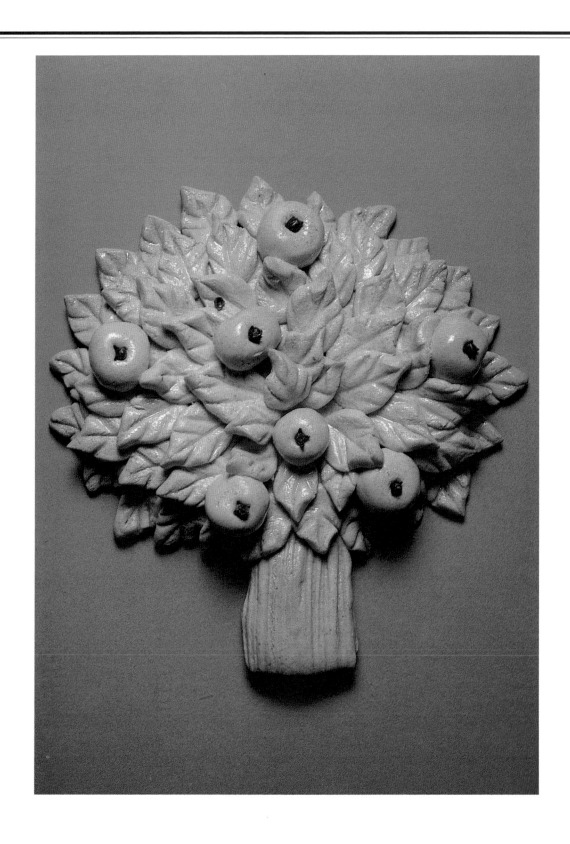

Garland

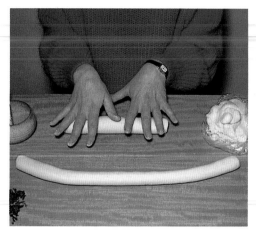

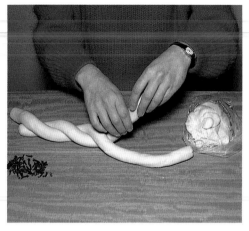

1. Make two rolls of dough approximately 50cm (20in) long and 2cm (¾ in) thick. To make sure that these are of an even thickness, spread your fingers out and gently move your hands towards each other whilst you are rolling. Do not rush this as a smooth finish is important. If it cracks, then reknead the dough and start again.

2. Carefully twist the two rolls together making sure that they do not stretch.

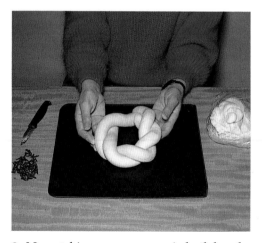

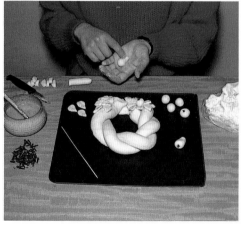

3. Now, taking your courage in both hands, bring the ends round to make a garland shape. Trim the ends and join them together using water. The join needs to be strong, but do not worry if it is not very neat. You can hide it later.

4. Make a series of leaves, apples, pears, and plums. To make a pear, just elongate an apple (see page 30) by rolling one end a little more. Roll plum shapes a little longer still and mark a line with the back of the knife. Add the leaves and fruits to the garland. It is now ready to bake, paint, and varnish.

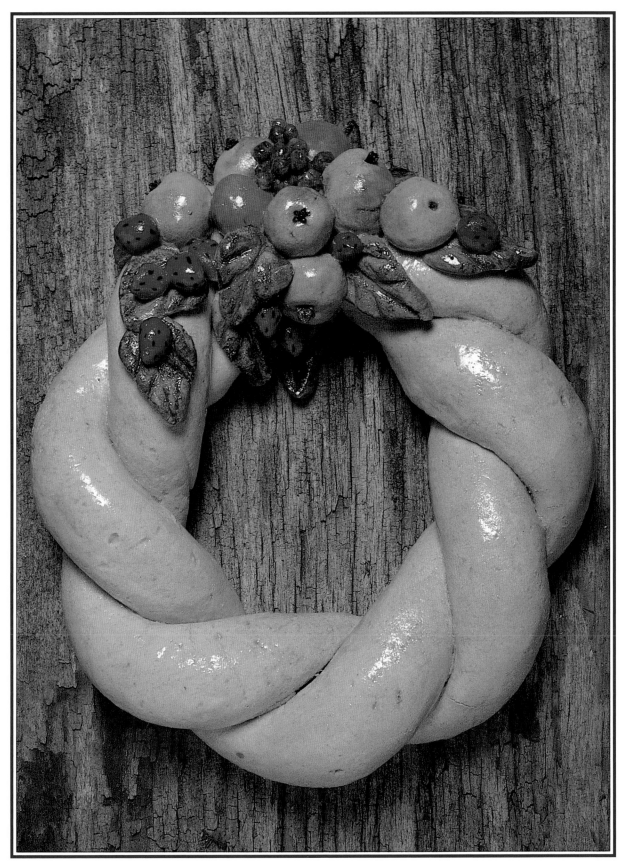

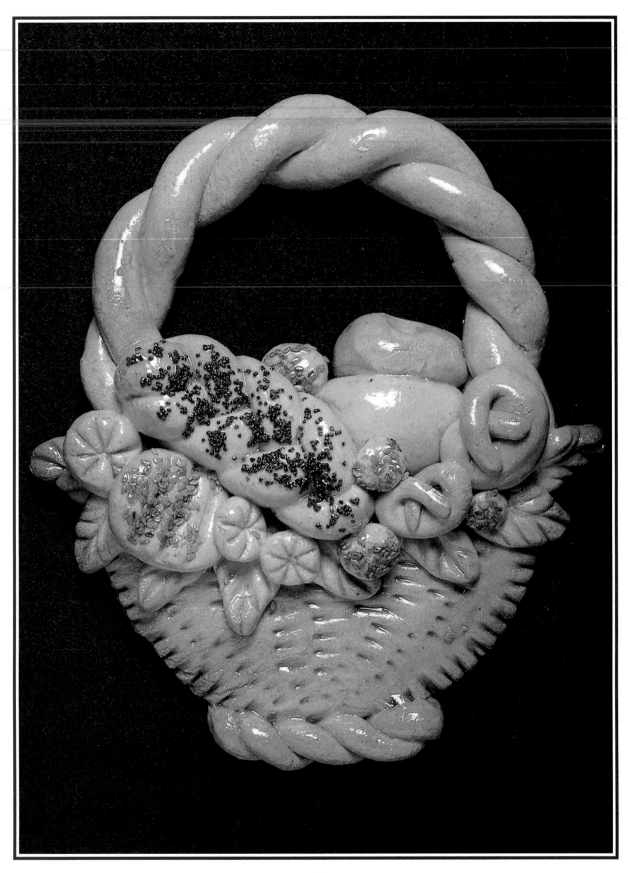

34

Three-dimensional bread basket

To make the basket, firstly make a double twist of dough for the base, and then make one for the rim. Next, connect the base and the rim with strips of dough, making sure that they are well joined with water. The bread shapes are simply larger versions of those shown on pages 34–5.

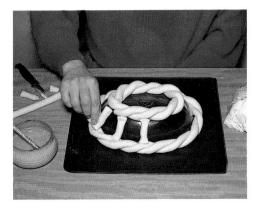

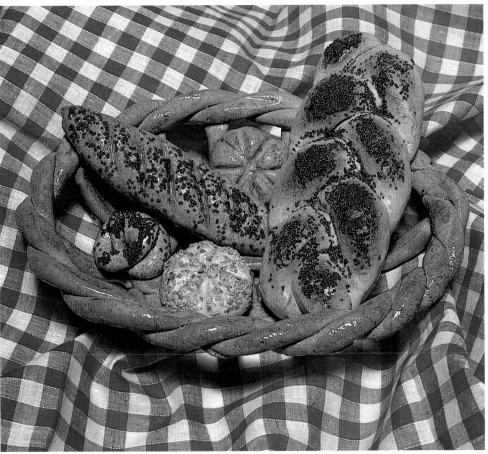

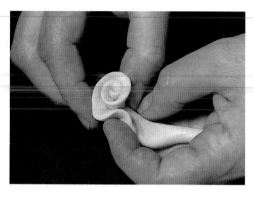

How to make roses

To make a rose bud, use a small roll of dough. Press it flat and pinch along the edge with your finger and thumb. The edge need not be straight. Roll it up to make a bud.

To make an open rose, roll the dough out into a thin sheet and cut out a series of small circles. I find that an icing nozzle is ideal for the job. If you blow through the little hole, then the circle comes away easily. Pinch the petals round the edge to take away that 'stamped out' look. Make the middle of the flower by twisting up one circle. Add further petals around the edge.

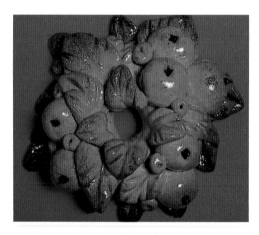

Candle holder

Make a small ring of dough for the base, leaving a hole approximately the size of a candle. Add fruits, flowers, or leaves. When the candle holder has been baked, trim the base of the candle to fit the hole. Make sure that you stand the holder on a plate or fireproof base before using it.

Napkin ring

Make the ring around a cardboard roll which has been covered with foil. If this is too big, then cut the roll and make it smaller. You can bake the ring on the roll, as cardboard does not burn in the oven. Make the decoration separately and stick it on before varnishing.

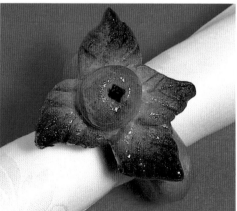

Roses in a basket

This basket is rather similar to the one shown on pages 34–5. The texture is made with two forks, and the bottom of the basket is simply a roll of dough with diagonal knife marks. When cutting out the basic basket shape, it is important to leave some dough at the top upon which to arrange the roses.

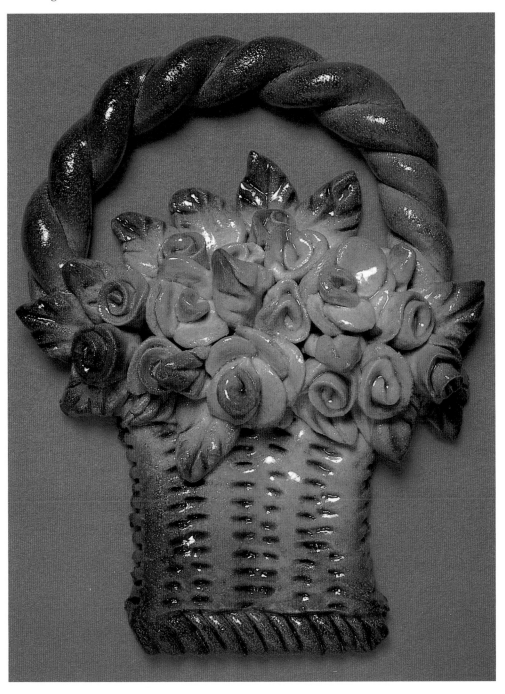

Bread in a basket

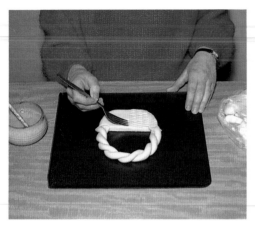

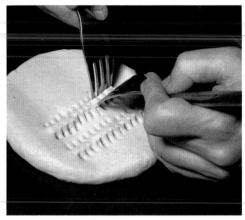

1. Roll out a sheet of dough and cut out the shape of a basket. Then, twist two rolls of dough together to make the handle, and use a fork to texture the basket.

2. Two forks can be used to create a different effect (see overleaf).

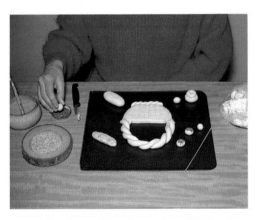

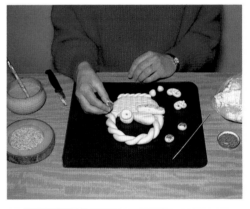

3. Add a thin twist of dough to the bottom of the basket. Next, make a variety of loaf and roll shapes, decorating them with sesame seeds and poppy seeds.

4. Starting at the edge of the basket, assemble the loaves. You may have to cut away some parts so that they appear to sit in the basket. Also, a few leaves may help the arrangement. The basket is now ready to bake and varnish.

Variations of this basket can be found on pages 15 and 36.

Scenes

It is fun to put several things together to make a scene. Here, I have used a figure, baskets, and bread, all of which can be found earlier in the book. You may find it easier to draw your design on aluminium foil before you start and then build the scene upon this. Also, when you assemble the baker and his baskets you will need to cut away parts that look too bulky.

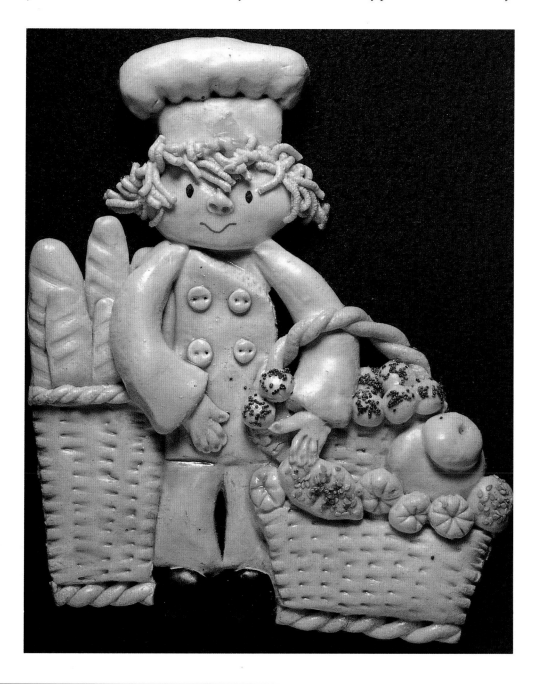

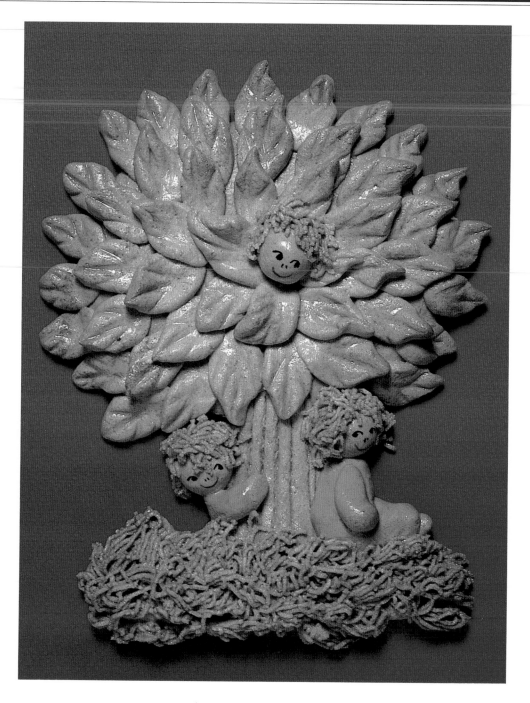

Children in a tree

In this scene, I have used figures and a tree. Roll out the dough and cut out the basic shape. Use a garlic press to make the grass. Next, add a ball for the head in the tree. The child peeping round the tree has only a head and an arm. The one sitting down has only one arm and one leg. The finished scene will need two hooks to support its weight.

Teddy bears' picnic

This scene would look lovely in a child's nursery. Of course, there are many other figures that you can make for children, such as television characters, pets, or even a favourite toy.

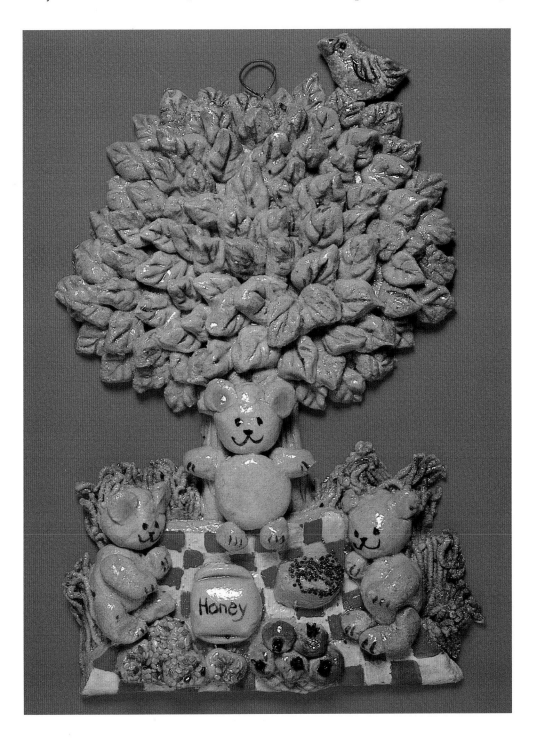

Story time

This makes an ideal gift for a nursery class teacher or a play-group leader. You can vary the number of children according to the number in the class. Before you start, sketch the layout on foil. This will help you to ensure that all of the figures can be fitted in. Next, roll out the number of heads that you want, making sure that they are all of the same size. Start with the teacher, then the bodies, heads, and legs. Lastly, add any arms for which you can still find room. Also, remember that a large scene such as this will need two hooks.

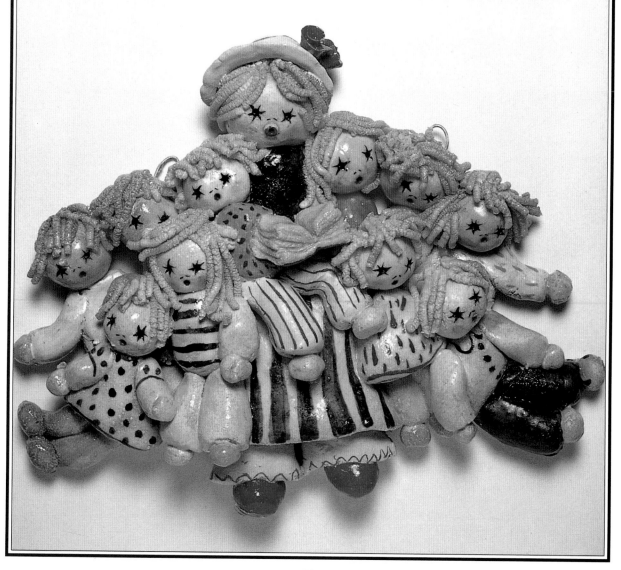

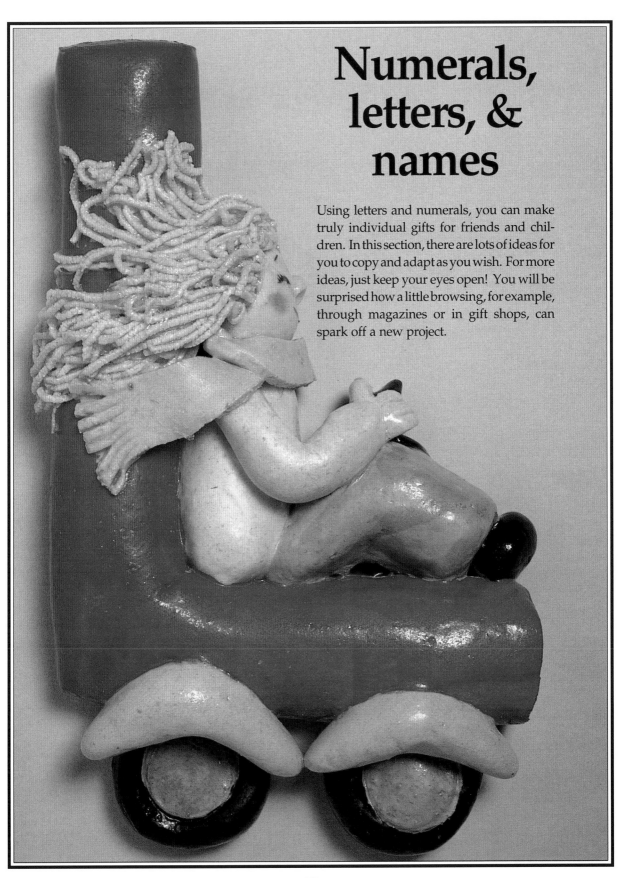

Numerals, letters, & names

Using letters and numerals, you can make truly individual gifts for friends and children. In this section, there are lots of ideas for you to copy and adapt as you wish. For more ideas, just keep your eyes open! You will be surprised how a little browsing, for example, through magazines or in gift shops, can spark off a new project.

Numerals & letters

Numerals and initial letters can be personalized simply by adding a decoration that is appropriate for the person you have in mind. For example, you could add a cat for a cat lover, a teddy bear for a child, or a book for a bookworm. Roll the dough smoothly and cut the sections of the letters or numerals. Then, simply join them together with water, making sure that the joins are firm.

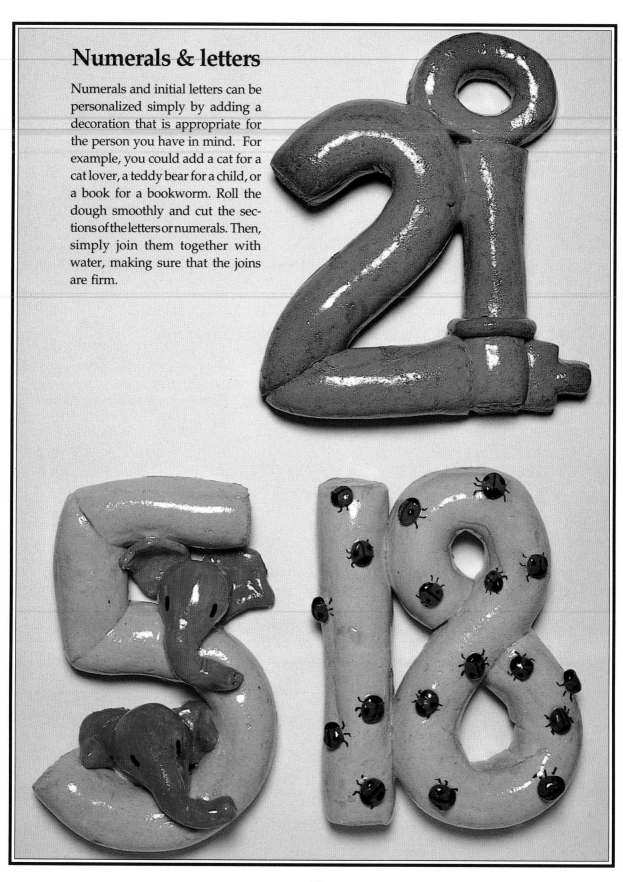

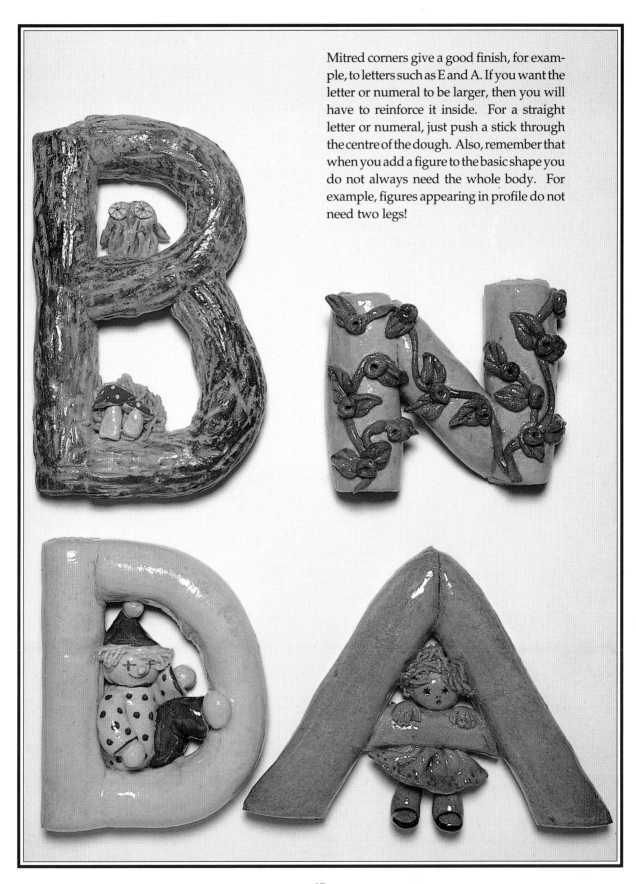

Mitred corners give a good finish, for example, to letters such as E and A. If you want the letter or numeral to be larger, then you will have to reinforce it inside. For a straight letter or numeral, just push a stick through the centre of the dough. Also, remember that when you add a figure to the basic shape you do not always need the whole body. For example, figures appearing in profile do not need two legs!

Names

Names are made simply by joining letters together. However, they can be rather spindly and easily broken. Here are some tips which will help you to make them stronger.

- Chunky letters are stronger than thin ones.
- Join the letters to each other in as many places as possible.
- Add a base line for added strength.
- Try overlapping letters. You may have to cut away some of the bulk when you do this.
- Play around with capitals and lower case letters. For example, a capital 'L' is easier to join than a lower case 'l'.
- Adding decorations, such as the dragon and the snail (see opposite), links the letters and makes the name stronger.

Name plaques also make unusual presents. However, do not make the plaque too big, as large, flat areas of dough are inclined to bubble or crack when baked. Once you have made the basic plaque, cut out the lengths of dough for the letters. Place them lightly on the plaque and rearrange them until you are happy with the result. Then, attach them firmly to the base with a little water. To give a decorative effect, you can use a stick to press the letters into the base (see the plaque on page 9).

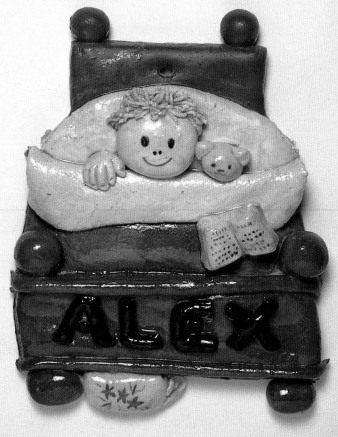

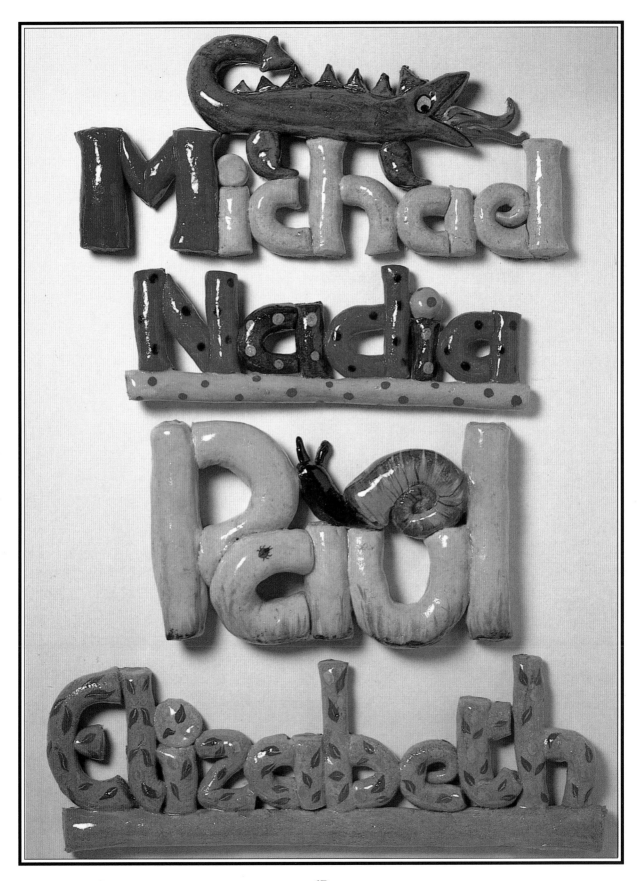

Index

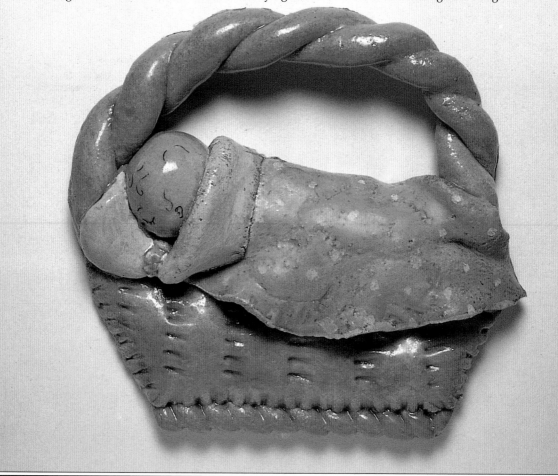